KEEP GOING→

10 WAYS TO STAY CREATIVE IN GOOD TIMES AND BAD

AUSTIN KLEON

WORKMAN PUBLISHING · NEW YORK

Library of Congress Cataloging-in-Publication Data is available.

ISBN 978-1-5235-0664-4

Workman books are available at special discounts when purchased in bulk for premiums and sales promotions as well as for fund-raising or educational use. Special editions or book excerpts can also be created to specification. For details, contact the Special Sales Director at the address below, or send an email to specialmarkets@workman.com.

Workman Publishing Co., Inc.
225 Varick Street
New York, NY 10014-4381

workman.com

WORKMAN is a registered trademark of Workman Publishing Co., Inc.

Printed in China

First printing April 2019

10 9 8 7 6 5 4 3 2 1

FOR MEGHAN + OWEN + JULES
(THE REASONS I KEEP GOING)

OVERHEARD ON THE TITANIC

o
s

Da ng
chee
na
w
se

"I mean, yes, we're sinking,"

But

r

M
Z

the

music

is
exceptional

"I think I need to keep being creative, not to prove anything but because it makes me happy just to do it . . . I think trying to be creative, keeping busy, has a lot to do with keeping you alive."

—*Willie Nelson*

I WROTE THIS BOOK BECAUSE I NEEDED TO READ IT.

A few years ago, I'd wake up every morning, check the headlines on my phone, and feel as if the world had gotten dumber and meaner overnight. Meanwhile, I'd been writing and making art for more than a decade, and it didn't seem to be getting any easier. *Isn't it supposed to get easier?*

Everything got better for me when I made peace with the fact that it might not *ever* get easier. The world is crazy. Creative work is hard. Life is short and art is long.

1

Whether you're burned out, starting out, starting over, or wildly successful, the question is always the same: How to keep going?

This book is a list of ten things that have helped me. I wrote it primarily for writers and artists, but I think the principles apply to anyone trying sustain a meaningful and productive creative life, including entrepreneurs, teachers, students, retirees, and activists. Many of the points are things I've stolen from others. I hope you'll find some things worth stealing, too.

There are no rules, of course. Life is an art, not a science. Your mileage may vary. Take what you need and leave the rest.

Keep going and take care of yourself.

I'll do the same.

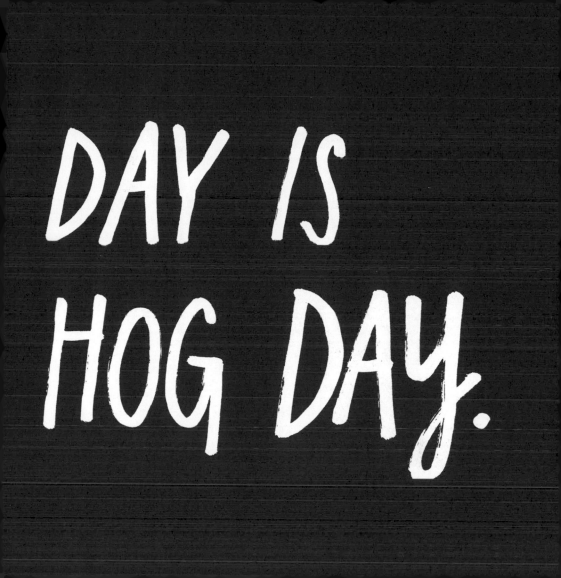

TAKE ONE DAY AT A TIME.

"None of us know what will happen. Don't spend time worrying about it. Make the most beautiful thing you can. Try to do that every day. That's it."

—Laurie Anderson

Whenever someone starts talking about "the creative journey," I roll my eyes.

It sounds too lofty to me. Too heroic.

The only creative journey I seem to go on is the ten-foot commute from the back door of my house to the studio in my garage. I sit down at my desk and stare at a blank piece of paper and I think, "Didn't I just do this yesterday?"

When I'm working on my art, I don't feel like Odysseus. I feel more like Sisyphus rolling his boulder up the hill. When I'm working, I don't feel like Luke Skywalker. I feel more like Phil Connors in the movie *Groundhog Day*.

For those of you who haven't seen it or need your memory refreshed, *Groundhog Day* is a 1993 comedy starring Bill Murray as Phil Connors, a weatherman who gets stuck in a time loop and wakes up every morning on February 2nd— Groundhog Day—in Punxsutawney, Pennsylvania, home of

Punxsutawney Phil, the famous groundhog who, depending on if he sees his shadow or not, predicts whether there will be six more weeks of winter. Phil, the weatherman, hates Punxsutawney, and the town becomes a kind of purgatory for him. He tries everything he can think of, but he can't make it out of town, and he can't get to February 3rd. Winter, for Phil, is endless. No matter what he does, he still wakes up in the same bed every morning to face the same day.

In a moment of despair, Phil turns to a couple drunks at a bowling alley bar and asks them, "What would you do if you were stuck in one place, and every day was exactly the same, and nothing that you did mattered?"

It's the question Phil has to answer to advance the plot of the movie, but it's also the question we have to answer to advance the plot of our lives.

I think how you answer this question is your art.

every

Day

is

created

from scratch

Now, I'm not the first person to suggest that *Groundhog Day* is perhaps *the* great parable of our time. Harold Ramis, the movie's director and cowriter, said he got endless letters from priests, rabbis, and monks, all praising the movie's spiritual message and claiming it for their own religion. But I think the movie has particular relevance for people who want to do creative work.

The reason is this: The creative life is *not* linear. It's not a straight line from point A to point B. It's more like a loop, or a spiral, in which you keep coming back to a new starting point after every project. No matter how successful you get, no matter what level of achievement you reach, you will never really "arrive." Other than death, there is no finish line or retirement for the creative person. "Even after you have achieved greatness," writes musician Ian Svenonius, "the infinitesimal cadre who even noticed will ask, 'What next?'"

The truly prolific artists I know always have that question answered, because they have figured out a *daily practice*—a

repeatable way of working that insulates them from success, failure, and the chaos of the outside world. They have all identified what they want to spend their time on, and they work at it every day, no matter what. Whether their latest thing is universally rejected, ignored, or acclaimed, they know they'll still get up tomorrow and do their work.

We have so little control over our lives. The only thing we can really control is what we spend our days on. What we work on and how hard we work on it. It might seem like a stretch, but I really think the best thing you can do if you want to make art is to pretend you're starring in your own remake of *Groundhog Day*: Yesterday's over, tomorrow may never come, there's just today and what you can do with it.

"Any man can fight the battles of just one day," begins a passage collected in Richmond Walker's book of meditations for recovering alcoholics, *Twenty-Four Hours a Day*. "It is only when you and I add the burden of those two awful eternities, yesterday and tomorrow, that we break

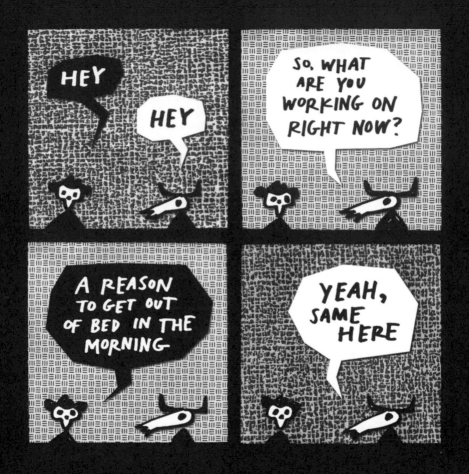

down. It is not the experience of today that drives men mad. It is remorse or bitterness for something which happened yesterday or the dread of what tomorrow may bring. Let us therefore do our best to live but one day at a time."

The creative journey is not one in which you're crowned the triumphant hero and live happily ever after. The real creative journey is one in which you wake up every day, like Phil, with more work to do.

"How we spend our days is, of course, how we spend our lives."

—Annie Dillard

ESTABLISH A DAILY ROUTINE.

"Relying on craft and routine is a lot less sexy than being an artistic genius. But it is an excellent strategy for not going insane."

—Christoph Niemann

There will be good days and bad days. Days when you feel inspired and days when you want to walk off a bridge. (And some days when you can't tell the difference.)

A daily routine will get you through the day and help you make the most of it. "A schedule defends from chaos and whim," writes Annie Dillard. "It is a net for catching days." When you don't know what to do next, your routine tells you.

When you don't have much time, a routine helps you make the little time you have count. When you have all the time in the world, a routine helps you make sure you don't waste it. I've written while holding down a day job, written full-time from home, and written while caring for small children. The secret to writing under all those conditions was having a schedule and sticking to it.

EVERY DAY:

- [] HEAR A LITTLE SONG

- [] READ A GOOD POEM

- [] SEE A FINE PICTURE

- [] SPEAK A FEW
 REASONABLE WORDS

— GOETHE

In his book *Daily Rituals*, Mason Currey catalogs the daily routines of 161 creative individuals: when they woke up, when they worked, what they ate, what they drank, how they procrastinated, and more. It's a wild collage of human behavior. Reading about the habits of writers alone is like visiting a human zoo. Kafka scribbled into the night while his family slept. Plath wrote in the morning before her children woke up. Balzac slugged fifty cups of coffee a day. Goethe sniffed rotten apples. Steinbeck had to sharpen twelve pencils before starting his work.

It's undeniably fun to read about the routines and rituals of creative people, but what becomes clear after a while is that there is no perfect, universal routine for creative work. "One's daily routine is a highly idiosyncratic collection of compromises, neuroses, and superstitions," Currey writes, "built up through trial and error and subject to a

variety of external conditions." You can't just borrow your favorite artist's daily routine and expect it to work for you. Everyone's day is full of different obligations—jobs, families, social lives—and every creative person has a different temperament.

To establish your own routine, you have to spend some time observing your days and your moods. Where are the free spaces in your schedule? What could you cut out of your day to make time? Are you an early riser or a night owl? (I've met very few people who love working in the afternoon. "I detest this mongrel time, neither day nor night," wrote Charles Dickens.) Are there silly rituals or superstitions that get you in a creative mood? (I'm writing these words with a pencil, painted to look like a cigarette, dangling from my lips.)

the Muse

is ready to

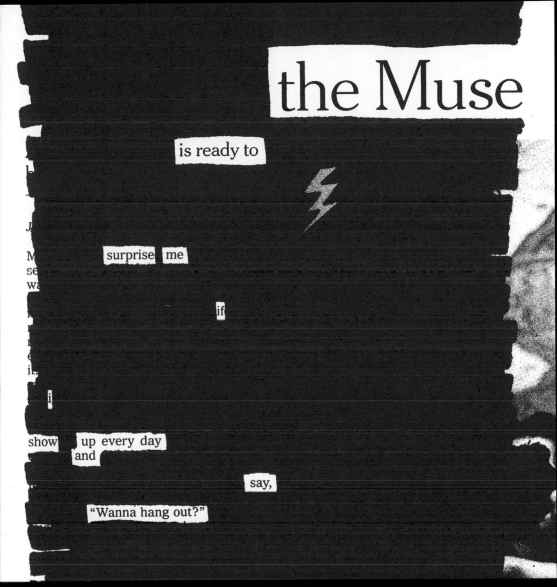

surprise me

if

i

show up every day
and

say,

"Wanna hang out?"

I suppose for some people a strict routine sounds like prison. But aren't we all, in a sense, "doing time?" When rapper Lil Wayne was in prison, I found myself envying his daily routine, which consisted of waking up at 11 a.m., drinking coffee, making phone calls, showering, reading fan mail, having lunch, making phone calls, reading, writing, having dinner, doing push-ups, listening to the radio, reading, and sleeping. "Man, I'll bet I could get a lot of writing done if I went to prison," I joked to my wife. (When I visited Alcatraz, I thought it would make the perfect writer's colony. *What a view!*)

A little imprisonment—if it's of your own making—can set you free. Rather than restricting your freedom, a routine *gives* you freedom by protecting you from the ups and downs of life and helping you take advantage of your limited time, energy, and talent. A routine establishes good habits that can lead to your best work.

Best of all, I think, is that when your days pretty much have the same shape, the days that don't have that shape become even more interesting. There's nothing like a good prison break, and playing hooky isn't as fun if you never go to school.

What your daily routine consists of is not that important. What's important is that the routine exists. Cobble together your own routine, stick to it most days, break from it once in a while for fun, and modify it as necessary.

"My hangovers are scheduled a year in advance."

—*John Waters*

MAKE LISTS.

"I make lists to keep my anxiety level down. If I write down fifteen things to be done, I lose that vague, nagging sense that there are an overwhelming number of things to be done, all of which are on the brink of being forgotten."

—*Mary Roach*

Lists bring order to the chaotic universe. I *love* making lists. Whenever I need to figure out my life, I make a list. A list gets all your ideas out of your head and clears the mental space so you're actually able to do something about them.

When I'm overwhelmed, I fall back on the old-fashioned to-do list. I make a big list of everything that needs to get done, I pick the most pressing thing to do, and I do it. Then I cross it off the list and pick another thing to do. Repeat.

Some of my favorite artists make "to-draw" lists. David Shrigley will make a huge list of fifty things to draw a week in advance. Having the list means he doesn't have to waste studio time worrying about what to make. "The simple thing I've learned over the years is just to have a starting point and once you have a starting point the work seems to make itself," he says.

HOW TO BE HAPPY

1. READ OLD BOOKS.

2. GO FOR LONG WALKS.

3. PLAY THE PIANO.

4. MAKE ART WITH KIDS.

5. WATCH SCREWBALL COMEDIES.

6. LISTEN TO SOUL MUSIC.

7. WRITE IN A DIARY.

8. TAKE NAPS.

9. LOOK AT THE MOON.

10. MAKE DUMB LISTS.

Leonardo da Vinci made "to-learn" lists. He'd get up in the morning and write down everything he wanted to learn that day.

When there's something I want to do in the future but don't have time for right now, I add it to what productivity expert David Allen calls a "Someday/Maybe" list. Writer Steven Johnson does this in a single document he calls a "spark file"—every time he has an idea, he adds it to the file, and then he revisits the list every couple of months.

Sometimes it's important to make a list of what you *won't* do. The punk band Wire could never agree on what they all liked, but they could agree on what they *didn't* like. So, in 1977, they sat down and made a list of rules: "No solos; no decoration; when the words run out, it stops; we don't chorus out; no rocking out; keep it to the point; no Americanisms." The list defined their sound.

When I need to make a decision, there's the pros-and-cons list. In 1772, Benjamin Franklin explained it to his pal Joseph Priestly: "Divide a half a sheet of paper by a line into two columns, writing over the one Pro, and over the other Con." When Charles Darwin was trying to figure out whether to get married? He made a pros-and-cons list.

When I'm stuck in the morning and I don't know what to write about in my diary, I'll modify the pros-and-cons list. I'll draw a line down the middle of the page, and in one column I'll list what I'm thankful for, and in the other column, I'll write down what I need help with. It's a paper prayer.

"A list is a collection with purpose," writes designer Adam Savage. I like to look back at the end of each year and see where I've been, so I'll make a "Top 100" list of favorite trips, life events, books, records, movies, etc. I stole this practice from cartoonist John Porcellino, who publishes a "Top 40"–style list in his zine, *King-Cat*. (He, too, is a big

list-maker; he'll keep long lists of stories and drawing ideas for the zine before he actually sits down to draw them.) Each list is like an organized diary of the year. It comforts me to look over previous years, to see what's changed and what hasn't.

When I need to keep myself spiritually on track, I'll make a version of my own Ten Commandments. A list of "Thou shalts" and "Thou shalt nots." Come to think of it, this book is one of them.

"Your list is your past and your future. Carry at all times. Prioritize: today, this week, and eventually. You will someday die with items still on your list, but for now, while you live, your list helps prioritize what can be done in your limited time."

—Tom Sachs

"Finish every day and be done with it. You have done what you could; some blunders and absurdities no doubt crept in; forget them as soon as you can. Tomorrow is a new day; you shall begin it well and serenely, and with too high a spirit to be cumbered with your old nonsense."

—*Ralph Waldo Emerson*

FINISH EACH DAY AND BE DONE WITH IT.

Not every day is going to turn out the way we want it to. All routines and to-do lists are aspirational. "You go diving for pearls," said Jerry Garcia, "but sometimes you end up with clams."

The important thing is to make it to the end of the day, no matter what. No matter how bad it gets, see it through to the end so you can get to tomorrow. After spending the day

with his five-year-old son, Nathaniel Hawthorne wrote in his diary, "We got rid of the day as well as we could." Some days you just have to get rid of as best as you can.

When the sun goes down and you look back on the day, go easy on yourself. A little self-forgiveness goes a long way. Before you go to bed, make a list of anything you *did* accomplish, and write down a list of what you want to get done tomorrow. Then forget about it. Hit the pillow with a clear mind. Let your subconscious work on stuff while you're sleeping.

A day that seems like waste now might turn out to have a purpose or use or beauty to it later on. When the video-game artist Peter Chan was young, he loved to draw, but he would crumple up his "bad" drawings in fits of frustration. His father convinced him that if he laid the "bad" drawings flat instead of crumpling them up, he could fit more of

Did we survive the day?

yes,

the key

question

on

those dark days

them in the wastebasket. After his father died, Chan found a folder labeled "Peter" in his father's possessions. When he looked inside, it was full of his old, discarded drawings. His father had snuck into his room and plucked the drawings he thought were worth saving from the wastebasket.

Every day is like a blank page: When you're finished filling it, you can save it, you can crumple it up, or you can slide it into the recycling bin and let it be. Only time will tell you what it was worth.

"Every day is a new deal.
Keep workin' and maybe
sump'n'll turn up."

—*Harvey Pekar*

DISCONNECT FROM THE WORLD TO CONNECT WITH YOURSELF.

"It's hard to find anything to say about life without immersing yourself in the world, but it's also just about impossible to figure out what it might be, or how to best say it, without getting the hell out of it again."

—Tim Kreider

Creativity is about *connection*—you must be connected to others in order to be inspired and share your own work—but it is also about *disconnection*. You must retreat from the world long enough to think, practice your art, and bring forth something worth sharing with others. You must play a little hide-and-seek in order to produce something worth being found.

Silence and solitude are crucial. Our modern world of push notifications, 24/7 news cycles, and constant contact is almost completely inhospitable to the kind of retreat artists must make in order to focus deeply on their work.

In *The Power of Myth*, Joseph Campbell said everyone should build a "bliss station":

> You must have a room, or a certain hour or so a day, where you don't know what was in the newspapers that morning, you don't know who your friends are, you don't know what you owe anybody, you don't know what anybody owes to you. This is a place

where you can simply experience and bring forth what you are and what you might be. This is the place of creative incubation. At first you may find that nothing happens there. But if you have a sacred place and use it, something eventually will happen.

Note that Campbell says you must have a room *or* a certain hour. A bliss station can be not just a *where*, but also a *when*. Not just a sacred *space*, but also a sacred *time*.

The deluxe package would include both a special room and a special hour that you enter it. But I think one can make up for a lack of the other. For example, say you have a tiny apartment you share with small children. There's no *room* for your bliss station, there's only *time*. When the kids are asleep or at school or day care, even a kitchen table can become a bliss station. Or, say your schedule is totally unpredictable and a certain time of day can't be relied upon—that's when a dedicated space that's ready for you at any time will come in handy.

THE BLISS STATION IN MY GARAGE

~~TURN ON~~ LOG OFF

~~TUNE IN~~ MUTE ALL

~~DROP OUT~~ CARRY ON

What's clear is that it's healthiest if we make a daily appointment to disconnect from the world so that we can connect with ourselves. Kids, jobs, sleep, and a thousand other things will get in the way, but we have to find our own sacred space, our own sacred time.

"Where is your bliss station?" Campbell asked. "You have to try to find it."

> "The greatest need of our time is to clean out the enormous mass of mental and emotional rubbish that clutters our minds and makes of all political and social life a mass illness. Without this housecleaning, we cannot begin to see. Unless we see, we cannot think."
>
> —Thomas Merton

YOU CAN BE WOKE WITHOUT WAKING TO THE NEWS.

"Everybody gets so much information all day long that they lose their common sense."

—Gertrude Stein

A friend of mine said he didn't know how long he could wake up to such horrible news every day. I suggested he shouldn't wake up to the news *at all*, and neither should anyone else.

There's almost nothing in the news that any of us need to read in the first hour of the day. When you reach for your phone or your laptop upon waking, you're immediately inviting anxiety and chaos into your life. You're also bidding adieu to some of the most potentially fertile moments in the life of a creative person.

Many artists have discovered that they work best upon waking, when their mind is fresh, and they're still in a quasi-dream state. The director Francis Ford Coppola says he likes to work in the early morning because "no one's gotten up yet or called me or hurt my feelings." The easiest way I get my feelings hurt is by turning on my phone first thing in the morning. Even on the rare occasion I don't get my feelings hurt, my time is gone and my brains are scattered.

Of course, the news has a way of scattering your brain regardless of when you catch up on it. In 1852, Henry David Thoreau complained in his diary that he had started reading a *weekly* newspaper and he felt that now he wasn't paying enough attention to his own life and work. "It takes more than a day's devotion to know and to possess the wealth of a day," he wrote. "To read of things distant and sounding betrays us into slighting these which are then apparently near and small." He decided his attention was too valuable, and gave up reading the weekly *Tribune*. Some 166 years after Thoreau complained about the *weekly* newspaper, I find that reading the Sunday paper is a healthy compromise: pretty much all the news I need to be an informed citizen.

If you're using your phone to wake up and it's ruining your mornings, try this: Before you go to bed, plug your phone into an outlet across the room, or somewhere out of arm's reach. When you wake up, try your best not to look at it.

There are so many better ways to wake up: Head to your bliss station, eat breakfast, stretch, do some exercises, take a walk, run, listen to Mozart, shower, read a book, play with your kids, or just be silent for a bit. Even if it's for fifteen minutes, give yourself some time in the morning to not be completely horrified by the news.

It's not sticking your head in the sand. It's retaining some of your inner balance and sanity so you can be strong and do your work.

You can be woke without waking up to the news.

"Keep your eye on your inner world and keep away from ads and idiots and movie stars."

—Dorothea Tanning

"The phone gives us a lot but it takes away three key elements of discovery: loneliness, uncertainty, and boredom. Those have always been where creative ideas come from."

—Lynda Barry

AIRPLANE MODE CAN BE A WAY OF LIFE.

In her ongoing project *Seat Assignment*, artist Nina Katchadourian uses long, disconnected plane rides to make art using only her camera phone, things she's packed for her trip, and materials she discovers on the airplane. She'll add a little sprinkled salt to in-flight magazine photos to create spooky images of spirits and ghosts. She'll fold up her sweater into gorilla faces. She'll dress herself in toilet paper and seat covers in the airplane bathroom and take selfies that recreate old Flemish-style portraits.

While so many of us struggle with smartphone addictions, Katchadourian has figured out how to turn the smartphone into a machine for making art. Best of all, nobody suspects what she's up to. "Once you pull out a real camera," she says, "it screams, 'I'm making art!'" Instead, people just assume she's another bored traveler killing time. *Seat Assignment* has taken place on more than *two hundred* flights since 2010, and as of the time of this writing, Katchadourian says that only *three* fellow passengers over the years have asked her what she's up to.

Every time I'm on an airplane now, I think about all the art I could be making. My writing teacher used to joke that the first rule of writing is to "apply ass to chair." Because you're forced to switch your electronic devices into airplane mode and you're literally buckled into a chair, I find planes to be a terrific place to get work done.

having become

bored out of her gourd

the artist

started working

But why not replicate the experience on the ground? You don't need to be on a plane to practice airplane mode: Pop in some cheap earplugs and switch your phone or tablet to airplane mode, and you can transform any mundane commute or stretch of captive time into an opportunity to reconnect with yourself and your work.

Airplane mode is not just a setting on your phone: It can be a whole way of life.

> "Almost everything will work again if you unplug it for a few minutes—including you."
>
> —Anne Lamott

"I must decline, for secret reasons."

—*E. B. White*

LEARN HOW TO SAY NO.

In order to protect your sacred space and time, you have to learn how to decline all sorts of invitations from the world. You must learn how to say "no."

Writer Oliver Sacks went so far as to tack up a huge "NO!" sign in his house next to the phone to remind him to preserve his writing time. The architect Le Corbusier spent mornings in his apartment painting and afternoons in his

office practicing architecture. "Painting every morning is what allows me to be lucid every afternoon," he said. He did everything he could to keep his two identities separate, even signing his paintings with his birth name, Charles-Édouard Jeanneret. A journalist once knocked on his apartment door during painting hours and asked to speak to Le Corbusier. Le Corbusier looked him right in the eye and said, "I'm sorry, he's not in."

Saying no is its own art form. Artist Jasper Johns answered invitations with a big custom-made "Regrets" stamp. Writer Robert Heinlein, critic Edmund Wilson, and the editors at *Raw* magazine all used form responses with checkboxes. These days, most of us receive invitations in the form of email, so it helps if you can have a "no thanks" template handy. In her piece "How to Graciously Say No to Anyone," Alexandra Franzen suggests the following: Thank the sender for thinking of you, decline, and, if you can, offer another form of support.

DEAR _____,

THANKS SO MUCH FOR
THINKING OF ME.

UNFORTUNATELY, I MUST
DECLINE.

BEST WISHES,

Say No

to

everyone

who

I s

not

me

Social media has created a human phenomenon called FOMO: the Fear Of Missing Out. It's the sense, scrolling through your feeds, that everybody out there is having a much better time than you are. The only antidote is JOMO: the Joy Of Missing Out. As writer Anil Dash explains, "There can be, and *should* be, a blissful, serene enjoyment in knowing, and celebrating, that there are folks out there having the time of their life at something that you might have loved to, but are simply skipping."

Saying "no" to the world can be really hard, but sometimes it's the only way to say "yes" to your art and your sanity.

"I paint with my back to the world."

—Agnes Martin

THE NOUN,
VERB.

"CREATIVE" IS NOT A NOUN.

"You have to have done something before you can be said to have done something. The title of artist or architect or musician needs to somehow be earned."

—Dave Hickey

Lots of people want to be the noun without doing the verb. They want the job title without the work.

Let go of the thing that you're trying to be (the noun), and focus on the actual work you need to be doing (the verb). Doing the verb will take you someplace further and far more interesting.

If you pick the wrong noun to aspire to, you'll be stuck with the wrong verb, too. When people use the word "creative" as a job title, it not only falsely divides the world into "creatives" and "non-creatives," but also implies that the work of a "creative" is "being creative." But being creative is never an end; it is a *means* to something else. Creativity is just a tool. Creativity can be used to organize your living room, paint a masterpiece, or design a weapon of mass destruction. If you only aspire to be a "creative," you might simply spend your time signaling that you are one: wearing designer eyeglasses, typing on your Macbook Pro, and Instagramming photos of yourself in your sun-drenched studio.

Job titles can mess you up. Job titles, if they're taken too seriously, will make you feel like you need to work in a way that befits the title, not the way that fits the actual work. Job titles can also restrict the kinds of work that you feel like you can do. If you only consider yourself a "painter," then what happens when you want to try out writing? If you only consider yourself a "filmmaker," what happens when you want to try sculpting?

If you wait for someone to give you a job title before you do the work, you might never get to do the work at all. You can't wait around for someone to call you an artist before you make art. You'll never make it.

If and when you finally get to be the noun—when that coveted job title is bestowed upon you by others—don't stop doing your verb.

Job titles aren't really for you, they're for others. Let other people worry about them. Burn your business cards if you have to.

Forget the nouns altogether. Do the verbs.

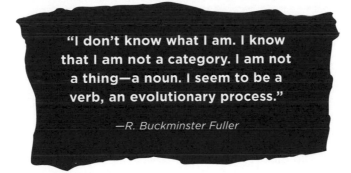

"I don't know what I am. I know that I am not a category. I am not a thing—a noun. I seem to be a verb, an evolutionary process."

—R. Buckminster Fuller

YOUR REAL WORK IS PLAY.

All children learn about the world through play. "Child's play" is a term we use to denote things that are easy, but if you actually watch children play, it is anything *but* easy. "Play is the work of the child," as Maria Montessori put it. When my children are playing, they are deeply invested in their work. They focus their gazes like laser beams. They scrunch up their faces in concentration. When they can't get their materials to do what they want them to do, they throw epic tantrums.

Their best play, however, is acted out with a kind of *lightness* and *detachment* from their results. When my son Jules was two, I spent a ton of time watching him draw. I noticed that he cared not one bit about the actual finished drawing (the noun)—all his energy was focused on drawing (the verb). When he'd made the drawing, I could erase it, toss it in the recycling bin, or hang it on the wall. He didn't really care.

He was also medium agnostic: he was just as happy with crayon on paper, marker on a whiteboard, chalk on the driveway, or, in a medium that put his parents' encouragement to the test, chalk on the outdoor couch cushions. (The drawings were so good my wife decided to embroider them. Again, he was completely indifferent.)

Play is the work of the child and it is also the work of the artist. I was once taking a walk in the Mission in San Francisco and stopped to chat with a street painter. When I thanked him for his time and apologized for interrupting his work, he said, "Doesn't feel like work to me. Feels more like play."

The great artists are able to retain this sense of playfulness throughout their careers. Art and the artist both suffer most when the artist gets *too heavy*, too focused on results.

There are some tricks to staying light and getting back to that childlike play state. The writer Kurt Vonnegut wrote a letter to a group of high school students and assigned them this homework: Write a poem and don't show it to anybody. Tear it up into little pieces and throw them into the trash can. "You will find that you have already been gloriously rewarded for your poem. You have experienced becoming, learned a lot more about what's inside you, and you have made your soul grow." That, said Vonnegut, was the whole

Looks Like

work.

but I think

of

it

as

play

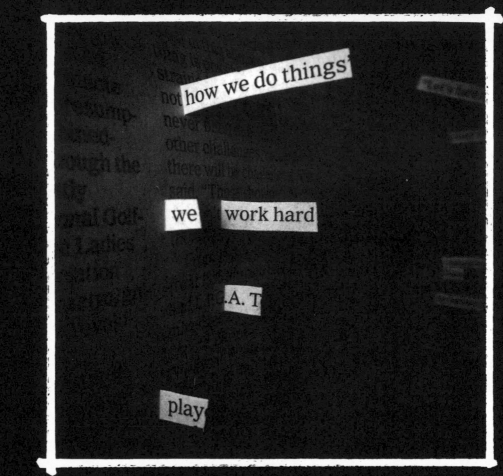

not how we do things

we work hard

.A. T

play

purpose of making art: "Practicing an art, no matter how well or badly, is a way to make your soul grow, for heaven's sake." Vonnegut repeated variations of that advice throughout his life. He would suggest to his daughter Nanette that she should make a piece of art and burn it "as a spiritual exercise." (There's something cathartic about burning your work: Artist John Baldessari, disgusted by his previous work, had it all cremated and put in a ceremonial urn.)

If you've lost your playfulness, *practice for practice's sake*. You don't have to go to such dramatic lengths as combustion. Musicians can jam without making a recording.

Writers and artists can type or draw out a page and throw it away. Photographers can take photos and immediately delete them.

Nothing makes play more fun than some new toys. Seek out unfamiliar tools and materials. Find something new to fiddle with.

Another trick: When nothing's fun anymore, try to make the *worst* thing you can. The ugliest drawing. The crummiest poem. The most obnoxious song. Making intentionally bad art is a ton of fun.

Finally, try hanging out with young kids. Play a game of hide-and-go-seek. Finger paint. Build a tower out of blocks and knock it down. Steal whatever works for you. When the writer Lawrence Weschler needs to figure out a

structure for one of his pieces, he'll play with his own set of wooden blocks. "My daughter is not allowed to play with these blocks," he says. "They are mine."

Don't get bogged down. Stay light. Play.

"You must practice being stupid, dumb, unthinking, empty. Then you will be able to DO . . . Try to do some BAD work—the worst you can think of and see what happens but mainly relax and let everything go to hell—you are not responsible for the world—you are only responsible for your work—so DO IT."

—Sol LeWitt to Eva Hesse

"God walks out of the
room when you're
thinking about money."

—*Quincy Jones*

PROTECT YOUR VALUABLES.

Here's a contemporary cultural phenomenon that drives me crazy.

You have a friend who knits beautiful scarves. Knitting is what he does to clear his mind and pass the time on his long train commute.

You have another friend who loves to bake cakes. Baking is what she does on nights and weekends to unwind after working at her stressful corporate job.

All three of you attend a birthday party. Your knitter friend gives the birthday girl the scarf he recently finished. It's absolutely beautiful.

What's the standard reaction these days?

"You could sell this on Etsy!"

After the birthday girl opens her gifts, your baker friend serves her cake. Everyone is moaning in delight.

What do they all say?

"You could start a bakery!"

We're now trained to heap praise on our loved ones by using market terminology. The minute anybody shows any talent for anything, we suggest they turn it into a profession. This is our best compliment: telling somebody they're so good at what they love to do they could make money at it.

We used to have hobbies; now we have "side hustles." As things continue to get worse in America, as the safety net gets torn up, and as steady jobs keep disappearing, the free-time activities that used to soothe us and take our minds off work and add meaning to our lives are now presented

after

he

started

to Make Money

the

work-

was poor,

to us as potential income streams, or ways out of having a traditional job.

I'm so insanely lucky right now. I live the dream, in a sense, because I get paid to do what I would probably do anyway for free. But things can get very, very tricky when you turn the thing you love into the thing that keeps you and your family clothed and fed. Everyone who's turned their passion into their breadwinning knows this is dangerous territory. One of the easiest ways to hate something you love is to turn it into your job: taking the thing that keeps you alive spiritually and turning it into the thing that keeps you alive *literally*.

You must be mindful of what potential impact monetizing your passions could have on your life. You might find that you're better off with a day job.

When you start making a living from your work, resist the urge to monetize every single bit of your creative practice.

Be sure there's at least a tiny part of you that's off-limits to the marketplace. Some little piece that you keep for yourself.

Times are always tough economically for artists and freelancers, so define the sort of lifestyle you want to live, budget for your expenses, and draw the line between what you will and won't do for money.

And remember: If you want maximum artistic freedom, keep your overhead low. A free creative life is not about living *within* your means, it's about living *below* your means.

"Do what you love!" cry the motivational speakers. But I think anybody who tells people to do what they love no matter what should also have to teach a money management course.

"Do what you love" + low overhead = a good life.

"Do what you love" + "I deserve nice things" = a time bomb.

"It's always good to have a hobby where there's no way to monetize it . . . So follow your dreams, but right up to the point where they become your job, and then run in the other direction."

—David Rees

"Not everything that can be counted
counts, and not everything that
counts can be counted."

—*William Bruce Cameron*

IGNORE THE NUMBERS.

Money is not the only measurement that can corrupt your creative practice. Digitizing your work and sharing it online means that it is subject to the world of online metrics: website visits, likes, favorites, shares, reblogs, retweets, follower counts, and more.

It's easy to become as obsessed with online metrics as money. It can then be tempting to use those metrics to decide what to work on next, without taking into account how shallow those metrics really are. An Amazon rank doesn't tell you whether someone read your book twice and loved it so much she passed it on to a friend. Instagram

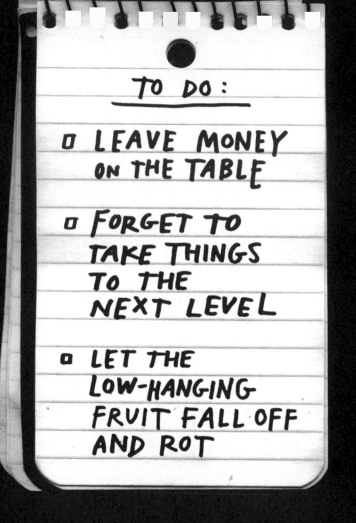

likes don't tell you whether an image you made stuck with someone for a month. A stream count doesn't equal an actual human being showing up to your live show and dancing.

What do clicks really mean in the grand scheme of things? All clicks have meant in the short term is that everything online is now clickbait, optimized for the short attention span. The quick hit.

I noticed a long time ago that there's actually very little correlation between what I love to make and share and the numbers of likes, favorites, and retweets it gets. I'll often post something I loved making that took me forever and crickets chirp. I'll post something else I think is sort of lame that took me no effort and it will go viral. If I let those metrics run my personal practice, I don't think my heart could take it very long.

If you share work online, try to ignore the numbers at least every once in a while. Increase the time between your sharing and receiving feedback. Post something and don't check the response for a week. Turn off the analytics for your blog and write about whatever you want. Download a browser plug-in that makes the numbers disappear from social media.

When you ignore quantitative measurements for a bit, you can get back to *qualitative* measurements. Is it good? Really *good*? Do *you* like it? You can also focus more on what the work does that *can't* be measured. What it does to your soul.

"No artist can work simply for results; he must also *like* the work of getting them."

—Robert Farrar Capon

"Don't make stuff because you want to make money—it will never make you enough money. And don't make stuff because you want to get famous—because you will never feel famous enough. Make gifts for people—and work hard on making those gifts in the hope that those people will notice and like the gifts."

—*John Green*

WHERE THERE IS NO GIFT, THERE IS NO ART.

You know what success is, or at least you have your own definition of it. (Mine: when my days look how I want them to look.)

"Suckcess," on the other hand, is success on somebody else's terms. Or undeserved success. Or when something you think sucks becomes successful. Or when success or chasing after it just plain starts to suck.

"Suckcess" is what poet Jean Cocteau was referring to when he said, "There is a kind of success worse than failure."

In his book *The Gift*, Lewis Hyde argues that art exists in both gift and market economies, but "where there is no gift, there is no art." When our art is taken over by market considerations—what's getting clicks, what's selling—it can quickly lose the gift element that makes it art.

We all go through cycles of disenchantment and re-enchantment with our work. When you feel as though you've lost or you're losing your gift, the quickest way to recover is to step outside the marketplace and *make gifts*.

There's nothing as pure as making something specifically for someone special. When my son Owen was five, he was obsessed with robots, so whenever I started hating myself and my work, I'd knock off for half an hour and make a

robot collage out of tape and magazines. When I gave him the robot, he'd often turn right around and make a robot for *me* We traded back and forth like that for a brief while until, as kids do, he dropped robots and became obsessed with something else. Those robots are still some of my favorite things I've ever made.

Try it: If you're bummed out and hating your work, pick somebody special in your life and make something for them. If you have a big audience, make them something special and give it away. Or maybe even better: Volunteer your time and teach someone else how to make what you make and do what you do. See how it feels. See whether it puts you in a better place.

WHO ARE YOU TRYING TO IMPRESS?

IF YOU GET LUCKY ONE DAY AND A BIG AUDIENCE SHOWS UP FOR WHAT YOU DO, CHANCES ARE THERE WILL BE ONLY A HANDFUL OF PEOPLE WHOSE OPINION MEANS ANYTHING TO YOU, SO YOU MIGHT AS WELL IDENTIFY THOSE PEOPLE <u>NOW</u>, MAKE GIFTS FOR THEM, AND <u>KEEP</u> MAKING GIFTS FOR THEM...

You never know when a gift made for a single person will turn into a gift for the whole world. Consider how many bestselling stories began their life as bedtime stories for specific children. A. A. Milne made up Winnie-the-Pooh for his son, Christopher Robin Milne. Astrid Lindgren's bedridden daughter Karin asked her to tell a story about some girl named Pippi Longstocking. C. S. Lewis convinced J. R. R. Tolkien to turn the fantastical stories he told his children into *The Hobbit.* The list goes on and on.

Making gifts puts us in touch with our gifts.

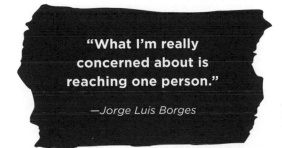

"What I'm really concerned about is reaching one person."

—*Jorge Luis Borges*

⑤ THE ORD
+ EXTRA
───────────
THE EXTRA

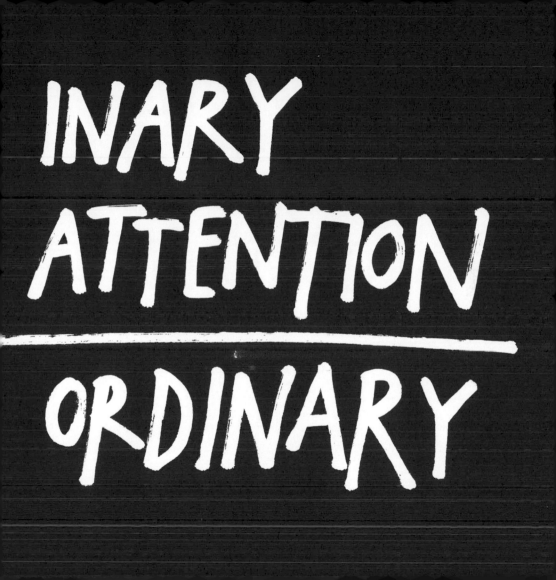

YOU HAVE EVERYTHING YOU NEED.

"It's as true today as it ever was:
He who seeks beauty will find it."

—*Bill Cunningham*

One of my art heroes was a nun.

In the 1960s, Sister Mary Corita Kent was an art teacher at Immaculate Heart College in Los Angeles. Inspired by a show of Andy Warhol's work, she started screen printing. She would take pictures of advertisements and signs all over the city—the stuff we usually think of as junk, clutter, and eye pollution—and she would transform those things by taking them out of their context, adding them to handwritten lyrics from pop songs and Bible verses, and printing them as if they were religious messages. She turned a bag of Wonder Bread into a message about taking communion. She stole the General Mills slogan, "The Big G Stands For Goodness," and made the "G" from the logo seem like it was referring to God. She cut the Safeway logo into two separate words and it became a sign showing the path of salvation. Finding God in all things is one of the tasks of the believer, and Kent found God in *advertising*, of all things. Kent took the manmade landscape

of Los Angeles—not necessarily the first place you'd look for beauty—and she found the beauty in it.

Kent said she made common things "uncommon." (She thought "uncommon" was a better term than "art.") "I don't think of it as art," she said, "I just make things I like bigger." She had a particular way of looking at the ordinary world, and she taught this way of looking to her students. In one of her assignments, she had students create what she called a "finder"—a piece of paper with a rectangle cut out of it to simulate a camera viewfinder. She would lead her students on field trips, teaching them to crop the world, to "see for the sake of seeing," and discover all the things that they'd never bothered to notice.

Really great artists are able to find magic in the mundane. Most of my favorite artists made extraordinary art out of ordinary circumstances and materials. Harvey Pekar spent the majority of his working life as a file clerk at the VA hospital in Cleveland, collecting stories and scribbling

telescopes see the light of the universe, using this trick known as Glass, it is our job to know where to look.

them into stick-figure scripts that would eventually become the comics in his masterpiece, *American Splendor*. Emily Dickinson stayed in her room and wrote her enduring poems on the backs of leftover envelope scraps. The Dada artist Hannah Höch used the sewing patterns from her day job in her collages. Sally Mann took gorgeous photos of her three children playing on their farm in Virginia. (Her friend, the painter Cy Twombly, used to sit outside the Walmart in Lexington and people watch for inspiration.)

It is easy to assume that if only you could trade your ordinary life for a new one, all your creative problems would be solved. If only you could quit your day job, move to a hip city, rent the perfect studio, and fall in with the right gang of brilliant misfits! Then you'd really have it made.

All this is, of course, wishful thinking. You do not need to have an extraordinary life to make extraordinary work. Everything you need to make extraordinary art can be found in your everyday life.

René Magritte said his goal with his art was "to breathe new life into the way we look at the ordinary things around us." This is exactly what an artist does: By paying extra attention to their world, they teach us to pay more attention to ours. The first step toward transforming your life into art is to start paying more attention to it.

"It's always been my philosophy to try to make art out of the everyday and ordinary . . . it never occurred to me to leave home to make art."

—Sally Mann

SLOW DOWN AND DRAW THINGS OUT.

"Let's slow down, not in pace or wordage but in nerves."

—*John Steinbeck*

It's impossible to pay proper attention to your life if you are hurtling along at lightning speed. When your job is to see things other people don't, you have to slow down enough that you can actually *look*.

In an age obsessed with speed, slowing down requires special training. After art critic Peter Clothier discovered meditation, he realized how little he was *actually looking* at art: "I would often catch myself spending more time with the wall label in a museum than with the painting I was supposed to be looking at!" Inspired by the slow food and slow cooking movements, he started leading "One Hour/One Painting" sessions in galleries and museums, in which he invited participants to gaze at a single artwork for one full hour. Slow looking caught on, and now several museums across the country hold slow looking events. The ethos is summed up on the Slow Art Day website: "When people look slowly . . . they make discoveries."

Slow looking is great, but I always need to be doing something with my hands, so drawing is my favorite tool for forcing myself to slow down and really look at life. Humans have drawn for thousands of years—it's an ancient practice that can be done with cheap tools available to everyone. You don't have to be an artist to draw. You just need an eye or two.

"Drawing is simply another way of seeing, which we don't really do as adults," says cartoonist Chris Ware. We're all going around in a "cloud of remembrance and anxiety," he says, and the act of drawing helps us live in the moment and concentrate on what's really in front of us.

Because drawing is really an exercise in seeing, you can suck at drawing and still get a ton out of it. In a blog post about picking up the habit of sketching later in his life, film critic Roger Ebert wrote, "By sitting somewhere and sketching something, I was forced to really look at it." He said his drawings were "a means of experiencing a place or a moment more deeply."

LOOK UP.

Drawing doesn't just help you see better, it makes you *feel* better. "An artist using a sketchbook always looks like a happy person," Ebert observed. "It's sublime," said author Maurice Sendak. "It's magic time, where all your weaknesses of character, the blemishes of your personality, whatever else torments you, fades away, just doesn't matter."

The camera phone is a wonderful tool for capturing things when we're out in the world, but drawing still offers us something unique. In the 1960s, photographer Henri Cartier-Bresson, legendary for capturing life on film in what he called "the Decisive Moment," went back to his first love: drawing. He wrote about the differences between his two loves in his book *The Mind's Eye*: "Photography is an immediate reaction, drawing is a meditation." In 2018, the British Museum started offering pencils and paper to visitors after they noticed an uptick in people interested in

sketching the art. One of the curators remarked, "I feel like you dwell on an object a lot more if you have a paper and pencil before you."

To slow down and pay attention to your world, pick up a pencil and a piece of paper and start drawing what you see. (The pencil's best feature is that it has no way of interrupting you with texts or notifications.) You might find that this helps you discover the beauty you've missed.

"If you draw," said the cartoonist E. O. Plauen, "the world becomes more beautiful, far more beautiful."

"Drawing is the discipline by which I constantly rediscover the world. I have learned that what I have not drawn, I have never really seen, and that when I start drawing an ordinary thing, I realize how extraordinary it is, sheer miracle."

—Frederick Franck

PAY ATTENTION TO WHAT YOU PAY ATTENTION TO.

"For anyone trying to discern what to do with their life: PAY ATTENTION TO WHAT YOU PAY ATTENTION TO. That's pretty much all the info you need."

—Amy Krouse Rosenthal

Your attention is one of the most valuable things you possess, which is why everyone wants to steal it from you. First you must protect it, and then you must point it in the right direction.

As they say in the movies, "Careful where you point that thing!"

What you choose to pay attention to is the stuff your life and work will be made of. "My experience is what I agree to attend to," psychologist William James wrote in 1890. "Only those items which I *notice* shape my mind."

We pay attention to the things we really care about, but sometimes what we really care about is hidden from us. I keep a daily diary for many reasons, but the main one is that it helps me pay attention to my life. By sitting down every morning and writing about my life, I pay attention to

it, and over time, I have a record of what I've paid attention to. Many diarists don't bother rereading their diaries, but I've found that rereading doubles the power of a diary because I'm then able to discover my own patterns, identify what I really care about, and know myself better.

If art begins with where we point our attention, a life is made out of paying attention to what we pay attention to.

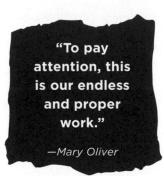

"To pay attention, this is our endless and proper work."

—Mary Oliver

Set up a regular time to pay attention to what you've paid attention to. Reread your diary. Flip back through your sketchbook. (The cartoonist Kate Beaton once said if she wrote a book about drawing she'd call it *Pay Attention to Your Drawings*.)

A Person

This was not lost on

is

who

I

want to

be

Scroll through your camera roll. Rewatch footage you've filmed. Listen to music you've recorded. (The musician Arthur Russell used to take long walks around Manhattan, listening to his own tapes on his Walkman.) When you have a system for going back through your work, you can better see the bigger picture of what you've been up to, and what you should do next.

If you want to change your life, change what you pay attention to. "We give things meaning by paying attention to them," Jessa Crispin writes, "and so moving your attention from one thing to another can absolutely change your future."

"Attention is the most basic form of love," wrote John Tarrant. When you pay attention to your life, it not only provides you with the material for your art, it also helps you fall in love with your life.

> "Tell me to what you pay attention and I will tell you who you are."

> —Jose Ortega y Gassett

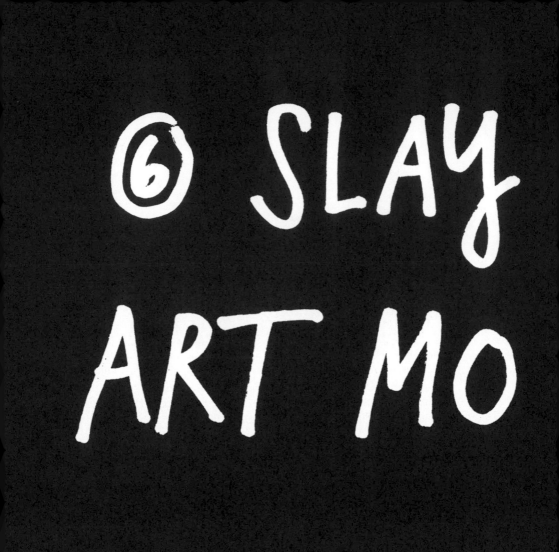

ART IS ~~FOR~~ LIFE
(NOT THE OTHER WAY AROUND).

"However glorious
the history of art, the
history of artists is quite
another matter."

—Ben Shahn

My nominee for one of the dumbest sentences ever spoken about art goes to *60 Minutes* commentator Andy Rooney, who said of Nirvana front man Kurt Cobain after his suicide, "No one's art is better than the person who creates it."

Take a quick dip into any one of the thousands of years of art history and you'll find that, no, actually, plenty of great art was made by jerks, creeps, assholes, vampires, perverts, and worse, all of whom left a trail of victims in their wake. To steal a term from Jenny Offill's *Dept. of Speculation*, these people are what we call "Art Monsters."

It can be hard and downright painful to grapple with the idea that people we find reprehensible in their personal lives might also be capable of producing work that is beautiful, moving, or useful to us. How we handle and process that information and how we choose to move forward is part of our work.

Now, we all have our own little Art Monsters inside us.

We're all complicated. We all have personal shortcomings. We're all a little creepy, to a certain degree. If we didn't believe that we could be a little better in our art than we are in our lives, then what, really, would be the point of art?

What is heartening right now, I think, is that our culture is having its moment of reckoning with Art Monsters. The terrible myth that being an absent parent, a cheater, an abuser, an addict, is somehow a prerequisite to or somehow excused by great work is slowly being torn down. If making great art ever gave anyone a Get Out of Jail Free card for their monstrous failures as a human being, I think those days are going away. And good riddance to them. Art Monsters are not necessary or glamorous and they are not to be condoned, pardoned, or emulated.

Great artists help people look at their lives with fresh eyes and a sense of possibility. "The purpose of being a serious writer is to keep people from despair," writes Sarah

POSSIBILITIES

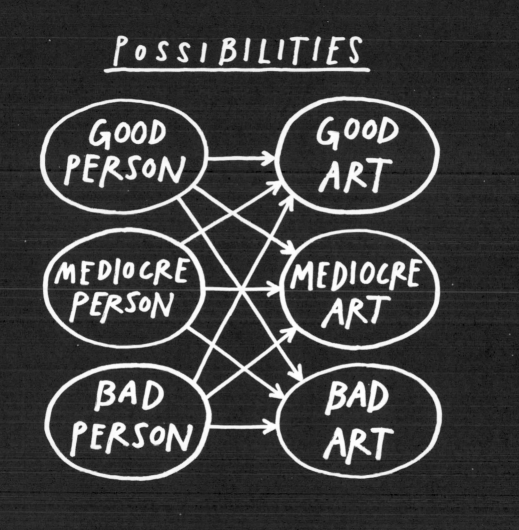

Manguso. "If people read your work and, as a result, choose life, then you are doing your job."

Quite simply: Art is supposed to make our lives better.

This is as true for the *making* of the art as it is for the art itself. If making your art is ruining anyone's life, including your own, it is not worth making.

"There's always going to be a temptation for people who are suffering to believe that to become an artist would be the solution when, in fact, it may be more of the problem," says writer and psychologist Adam Phillips. "There are a number of people whom you might think of as casualties of the myth of the artist. They really should have done something else."

You might not be meant to be an artist. "You might be meant to teach kids math or raise money for a food bank or start a company that makes Rubik's Cubes for babies," writes comedian Mike Birbiglia. "Don't rule out quitting.

There is going to be an insane amount of work ahead, and your time might be spent better elsewhere."

If making your art is adding net misery to the world, walk away and do something else. Find something else to do with your time, something that makes you and the people around you feel more alive.

The world doesn't necessarily need more great artists. It needs more decent human beings.

Art is *for* life, not the other way around.

> **"I am for an art that helps old ladies across the street."**
>
> —Claes Oldenburg

ALLOWED

NGE

MIND.

"The test of a first-rate intelligence is the ability to hold two opposed ideas in the mind at the same time, and still retain the ability to function. One should, for example, be able to see that things are hopeless and yet be determined to make them otherwise."

—F. Scott Fitzgerald

TO CHANGE IS TO BE ALIVE.

I was reading a newspaper article about climate change and a former skeptic said, "If you've never changed your mind about something, pinch yourself; you may be dead."

When was the last time you changed your mind about something? We're afraid of changing our minds because we're afraid of the consequences of changing our minds. What will people think?

In this country, you're supposed to have your ideas and stick with them and defend them with your life. Take our politics, for example. If a politician changes their mind publicly, it's

a sign of weakness. A sign of defeat. And you don't want to change your mind too much, heaven forbid, because then you're wishy-washy.

Social media has turned us all into politicians. And *brands*. Everyone's supposed to be a *brand* now, and the worst thing in the world is to be *off-brand*.

But to be *on brand* is to be 100 percent certain of who you are and what you do, and certainty, in art *and* in life, is not only completely overrated, it is also a roadblock to discovery.

Uncertainty is the very thing that art thrives on. The writer Donald Barthelme said that the artist's natural state is one of *not-knowing*. John Cage said that when he was not working he thought he knew something, but when he was

> **"I'm making explorations. I don't know where they're going to take me."**
>
> —*Marshall McLuhan*

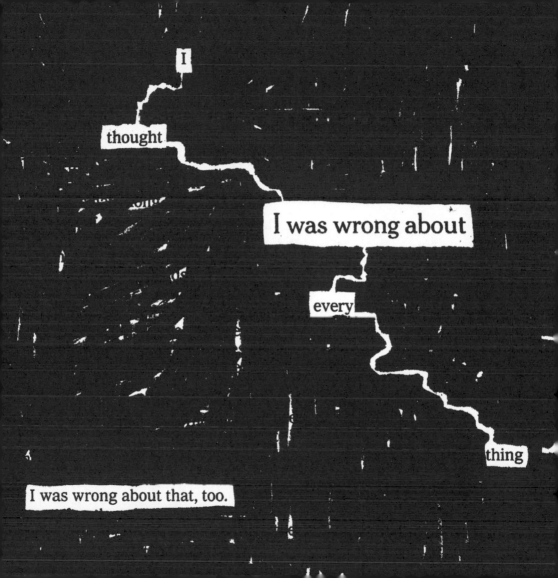

I

thought

I was wrong about

every

thing

I was wrong about that, too.

THE DUNNING-KRUGER PRAYER

LET ME BE SMART ENOUGH
TO KNOW HOW DUMB I AM
AND GIVE ME THE COURAGE
TO CARRY ON ANYWAY

* THE DUNNING-KRUGER EFFECT IS A PSYCHOLOGICAL PHENOMENON SUMMARIZED BY
COMEDIAN JOHN CLEESE: " STUPID PEOPLE HAVE NO IDEA HOW STUPID THEY ARE."

working, it was clear that he didn't know anything. "This has been my job in a way," says screenwriter Charlie Kaufman. "I sit at my desk and I don't know what to do."

You start each work not knowing exactly where you're going or where you'll end up. "Art is the highest form of hope," said painter Gerhard Richter. But hope is not about knowing how things will turn out—it is moving forward in the face of uncertainty. It's a way of *dealing* with uncertainty. "Hope is an embrace of the unknown and the unknowable," writes Rebecca Solnit. To have hope, you must acknowledge that you don't know everything and you don't know what's going to happen. That's the only way to keep going and the only way to keep making art: to be open to possibility and allow yourself to be changed.

Of course, to change your mind is to do some real *thinking*. Thinking requires an environment in which you can try out all sorts of ideas and not be judged for them. To change your mind, you need a good place to have some bad ideas.

The internet, unfortunately, is no longer a safe place to do any kind of experimental thinking, particularly for somebody with an audience or any kind of "brand." (That awful word! As if we're all cattle with our owner's mark burned into our flesh.)

No, if you're going to change your mind, you might have to go *off-brand*, and *offline* is the place to be off-brand. Your bliss station, your studio, a paper journal, a private chat room, a living room full of trusted loved ones: These are the places to really think.

LIKE-MINDED VS. LIKE-HEARTED

"The world needs you at the party starting real conversations, saying, 'I don't know,' and being kind."

—Charlie Kaufman

I WILL NOT ARGUE WITH STRANGERS ON THE INTERNET.
I WILL NOT ARGUE WITH STRANGERS ON THE INTERNET.
I WILL NOT ARGUE WITH STRANGERS ON THE INTERNET.
I WILL NOT ARGUE WITH STRANGERS ON THE INTERNET.
I WILL NOT ARGUE WITH STRANGERS ON THE INTERNET.
I WILL NOT ARGUE WITH STRANGERS ON THE INTERNET.
I WILL NOT ARGUE WITH STRANGERS ON THE INTERNET.
I WILL NOT ARGUE WITH STRANGERS ON THE INTERNET.
I WILL NOT ARGUE WITH STRANGERS ON THE INTERNET.
I WILL NOT ARGUE WITH STRANGERS ON THE INTERNET.
I WILL NOT ARGUE WITH STRANGERS ON THE INTERNET.
I WILL NOT ARGUE WITH STRANGERS ON THE INTERNET.
I WILL NOT ARGUE WITH STRANGERS ON THE INTERNET.
I WILL NOT ARGUE WITH STRANGERS ON THE INTERNET.
I WILL NOT ARGUE WITH STRANGERS ON THE INTERNET.
I WILL NOT ARGUE WITH STRANGERS ON THE INTERNET.

"Think for yourself!" goes the cliché. But the truth is: We can't. We need other people to help us think.

"To think independently of other human beings is impossible," writes Alan Jacobs in his book *How to Think*. "Thinking is necessarily, thoroughly, and wonderfully social. Everything you think is a response to what someone else has thought and said."

The trouble is that we're increasingly becoming a culture that is clustering into like-minded communities and networks. Offline, this plays out in where people live, whether by choice or necessity. Online, it plays out in what websites we visit, who we choose to follow, and how the algorithms of online networks are fine-tuned to show us what they think we want to see.

Interacting with people who don't share our perspective forces us to rethink our ideas, strengthen our ideas, or trade our ideas for better ones. When you're only interacting with like-minded people all the time, there's less and less opportunity to be changed. Everybody knows that feeling you get when you're hanging out with people who love the same art, listen to the same music, and watch the same movies: It's comforting at first, but it can also become incredibly boring and ultimately stifling.

Jacobs recommends that if you really want to explore ideas, you should consider hanging out with people who aren't so much *like-minded* as *like-hearted*. These are people who are "temperamentally disposed to openness and have habits of listening." People who are generous, kind, caring, and thoughtful. People who, when you say something, "think about it, rather than just simply react." People you feel good around.

A reader once sent me a note remarking that while he didn't share my politics, he felt he was able to really listen to what I had to say, rather than tuning out what he didn't want to hear. He suspected it had to do with the creative spirit, that connection you feel with another person you know is trying their best to bring new, beautiful things into the world.

Try your best to seek out the like-hearted people with whom you feel this connection.

VISIT THE PAST.

"Every age has its own outlook. It is specially good at seeing certain truths and specially liable to make certain mistakes. We all, therefore, need the books that will correct the characteristic mistakes of our own period. And that means the old books . . . To be sure, the books of the future would be just as good a corrective as the books of the past, but unfortunately we cannot get at them."

—C. S. Lewis

142

Most everybody alive is so obsessed with what's new that they all think about the same things. If you're having trouble finding people to think with, seek out the dead. They have a lot to say and they are excellent listeners.

Read old books. Human beings have been around for a long time, and almost every problem you have has probably been written about by some other human living hundreds if not thousands of years before you. The Roman statesman and philosopher Seneca said that if you read old books, you get to add all the years the author lived onto your own life. "We are excluded from no age, but we have access to them all," he said. "Why not turn from this brief and transient spell of time and give ourselves wholeheartedly to the past, which is limitless and eternal and can be shared with better men than we?" (He wrote that almost two thousand years ago!)

It's amazing how little human life changes. When I read Lao Tzu's *Tao Te Ching*, I marvel at how every ancient poem is basically a withering commentary on our contemporary

IF YOU CAN'T COME UP WITH YOUR OWN IDEA:

① IDENTIFY A POPULAR IDEA THAT YOU DESPISE AND WOULD LIKE TO DESTROY.

② FIND AN OLD OPPOSITE IDEA THAT EVERYONE'S FORGOTTEN AND RESURRECT IT.

politicians. A dip into Henry David Thoreau's journals paints a portrait of a plant-loving man who is overeducated, underemployed, upset about politics, and living with his parents—he sounds exactly like one of my fellow millennials!

We have such short memories. You don't have to go that far back into the past to discover things we've already forgotten about. Cracking a book that's only a quarter of a century old can be like opening a chest of buried treasure.

If you want a quick way to escape the noise of contemporary life, break out of your like-minded bubble, and do some good thinking, just visit the past for a bit. It's inexhaustible: Every day, we're making more and more of it.

(8) WHEN TIDY

KEEP YOUR TOOLS TIDY AND YOUR MATERIALS MESSY.

"The disorder of the desk, the floor; the yellow Post-it notes everywhere; the whiteboards covered with scrawl: all this is the outward manifestation of the messiness of human thought."

—Ellen Ullman

This is a bad time to be a pack rat. The propaganda against clutter and the mania for tidying has been whipped up by TV shows like *Hoarders* and *Storage Wars* and countless blogs that fetishize orderly studios and perfect workspaces with "things organized neatly," culminating in Marie Kondo's gigantic bestseller, *The Life-Changing Magic of Tidying Up*. While Kondo's tips can work wonders on your sock drawer or your kitchen pantry, I have serious doubts about their usefulness to artists.

My studio, like my mind, is always a bit of a mess. Books and newspapers are piled everywhere, pictures are torn out and stuck on the wall, cut-up scraps litter the floor. But it's not an accident that my studio is a mess. I *love* my mess. I *intentionally cultivate* my mess.

Creativity is about connections, and connections are not made by siloing everything off into its own space. New ideas are formed by interesting juxtapositions, and interesting juxtapositions happen when things are *out of place*.

You may think that if your studio is tidy, it will free you up to be *more efficient*, and therefore, you will *produce more*. Maybe that will help you in the execution stage of your work if you're, say, a printmaker pulling prints, but it won't help you come up with an interesting design for the next print. It's always a mistake to equate productivity and creativity. They are not the same. In fact, they're frequently at odds with each other: You're often most creative when you're the least productive.

There is, of course, such a thing as too much clutter. It's hard to work if you can't find the things you need when you need them. French chefs practice something called *mise en place*, which means "set in place." It's about planning and preparation: making sure all the ingredients and tools you need are ready before you set to work. "*Mise en place* is the religion of all good line cooks," Anthony Bourdain wrote in *Kitchen Confidential*. "Your station, and its condition, its state of readiness, is an extension of your nervous system."

SURROUND YOURSELF WITH
THE MESS OF WHAT YOU LOVE

That's the key word we can steal from chefs: *readiness*. Most of us don't have hungry diners or health inspectors to worry about. We don't have to keep our spaces perfectly clean and tidy. We just have to keep them ready for when we want to work. Cartoonist Kevin Huizenga makes the point that having your studio organized does not mean it needs to *look* organized. "If papers everywhere on the floor makes working easier right now, because you need to constantly refer to them, then they should stay there."

There's a balance in a workspace between chaos and order. My friend John T. Unger has the perfect rule: Keep your tools organized and your materials messy. "Keep your tools very organized so you can find them," he says. "Let the materials cross-pollinate in a mess. Some pieces of art I made were utter happenstance, where a couple items came together in a pile and the piece was mostly done. But if you can't lay your hands right on the tool you need, you can blow a day (or your enthusiasm and inspiration) seeking it."

TIDYING IS EXPLORING.

"I can never find what I want, but the benefit is that I always find something else."

—Irvine Welsh

I keep one of Brian Eno and Peter Schmidt's "Oblique Strategies" on a big sign above my desk:

WHEN IN DOUBT, TIDY UP.

Note that it says "when in doubt," not "always." Tidying up is for when I'm stalled out or stuck. Tidying up a studio is—sorry, Ms. Kondo—not life-changing or magical. It's just a form of *productive procrastination*. (Avoiding work by doing other work.)

The best thing about tidying is that it busies my hands and loosens up my mind so that I either a) get unstuck or solve a new problem in my head, or b) come across something in the mess that leads to new work. For example, I'll start tidying and unearth an unfinished poem that's been buried in a stack of papers, or an unfinished drawing that was blown across the garage by the air conditioner.

The best studio tidying is a kind of *exploring*. I rediscover things as I work my way through the clutter. The reason

I tidy is not really to clean, but to come into contact with something I've forgotten which I can now use.

This is a slow, dreamy, ruminative form of tidying. When I come across a long-lost book, for example, I flip to random pages and see if they have anything to tell me. Sometimes scraps of paper fall out of the book like a secret message from the universe.

I often stop tidying because I get swept up in reading. This is the exact opposite of what Marie Kondo prescribes. When going through your books, she says, "Make sure you don't start reading it. Reading clouds your judgment." Heaven forbid!

Tidying in the hope of obtaining perfect order is stressful work. Tidying without worrying too much about the results can be a soothing form of play.

When in doubt, tidy up.

SLEEP TIDIES UP THE BRAIN.

"Naps are essential to my process. Not dreams, but that state adjacent to sleep, the mind on waking."

—William Gibson

napping is considered a tactic, in My factory,

Scientists and philosophers have long wondered about sleep and what it's for. They're slowly catching up to what artists have known all along: Sleep is an excellent tool for tidying up your brain. When you sleep, your body literally flushes out the junk in your head. Neuroscientists have explained that cerebrospinal fluid in your brain starts flowing more rapidly when you sleep, clearing out the toxins and bad proteins that build up in your brain cells.

Naps are the secret weapon of many artists. "It's mostly napping," says filmmaker Ethan Coen of his and his brother Joel's creative process. I consider naps to be another form of magical tidying that *seems* unproductive but often leads to new ideas.

Not all naps are created equal. There are lots of ways to take a nap. Salvador Dalí liked to nap while holding a spoon. As he dozed off, he'd drop the spoon and wake up, but still be in the dreamlike state he needed for his surreal paintings. Writer Philip Roth said he learned his nap technique from

his father: Take your clothes off and pull a blanket over you, and you sleep better. "The best part of it is that when you wake up, for the first fifteen seconds, you have no idea where you are," Roth said. "You're just alive. That's all you know. And it's bliss, it's absolute bliss."

Me, I like the "caffeine nap": Drink a cup of coffee or tea, lie down for fifteen minutes, and get back to work when the caffeine has kicked in.

"What a pity one cannot sleepwrite on the ceiling with one's finger or lifted toe."

—Denton Welch

"This is an age of divorce. Things that belong together have been taken apart. And you can't put it all back together again. What you can do is the only thing that you can do. You take two things that ought to be together and you put them together."

—*Wendell Berry*

LEAVE THINGS BETTER THAN YOU FOUND THEM.

The greatest form of magical tidying that you can do is outside your studio or workspace: the tidying up of your wider world.

The writer David Sedaris is a born tidier. He tells childhood stories about vacuuming and cleaning up after his siblings. When he sold his first book, he was cleaning houses in Manhattan. Now he's a rich bestselling author and lives in a village west of London. You know how he spends most of his day? Picking up trash on the side of the road.

That's right: One of our most popular living authors estimates that he spends three to eight hours a day in the service of waste management. Sedaris has picked up so much trash that the locals literally named a garbage truck after him: "Pig Pen Sedaris." He's best known to his neighbors as a litter picker. When the *West Sussex County Times* wrote about him, they didn't even mention he was a writer.

What's funny is that Sedaris's litter picking totally fits into his writing work. Sedaris, like many artists, is a scavenger. He collects the discarded debris from the chaos of life—overheard bits of dialogue and overlooked experiences—and recycles them into essays. (His collection of diaries is appropriately titled *Theft by Finding*.) Some of his diaries, which he prints out and binds into books every season, contain pieces of the trash he comes across on his walks.

Art is not *only* made from things that "spark joy." Art is also made out of what is ugly or repulsive to us. Part of the artist's job is to help tidy up the place, to make order out of chaos, to turn trash into treasure, to show us beauty where we can't see it.

I find it instructive, sometimes, to think about some of the slogans we use for creative work.

MAKE YOUR MARK.

PUT A DENT IN THE UNIVERSE.

MOVE FAST AND BREAK THINGS.

These slogans presuppose that the world is in need of marking or denting or breaking and that the cosmic purpose of human beings is *vandalism*.

Things are already a mess out there. We've made enough of a mark on this planet. What we need are fewer vandals and more cleanup crews. We need art that tidies. Art that mends. Art that repairs.

Let's find some better slogans. Maybe we could look to medicine:

FIRST, DO NO HARM.

Or maybe we could lift the language from signs you see in parks:

LEAVE THINGS BETTER THAN YOU FOUND THEM.

It'd be a start.

(9) DEMONS FRESH

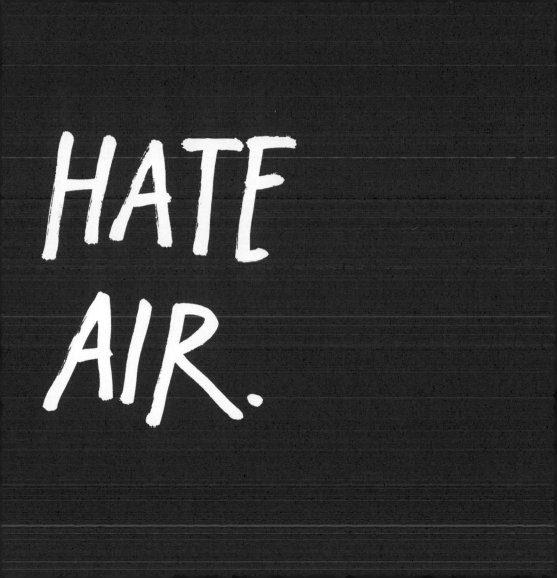

"I walked myself into
my best thoughts."

—*Søren Kierkegaard*

TO EXERCISE IS TO EXORCISE.

Almost every morning, rain or shine, my wife and I load our two sons into a red double stroller and we take a three-mile walk around our neighborhood. It's often painful, sometimes sublime, but it's absolutely essential to our day. We talk. We make plans. We rant about politics. We stop to chat with neighbors or admire the suburban wildlife.

Our morning walk is where ideas are born and books are edited. It's so crucial that we go for our walk that we've adopted the unofficial United States Postal Service motto as

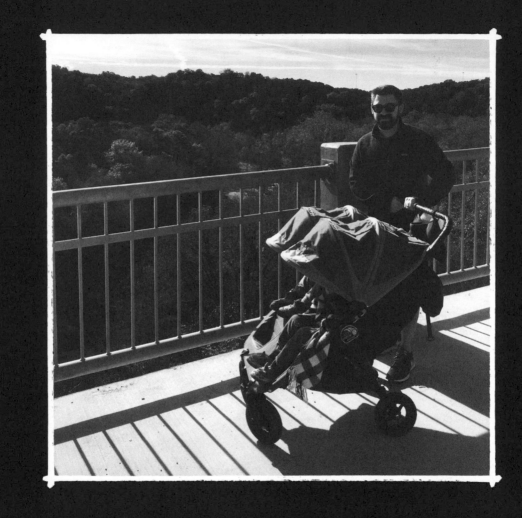

our own: "Neither snow nor rain nor heat nor gloom . . . stays these couriers from the swift completion of their appointed rounds." We won't set morning appointments or meetings before we take a walk. Whenever we meet a neighbor, the conversation often starts with, "Are you the couple with the big red stroller?"

Walking really is a magic cure for people who want to think straight. "Solvitur ambulando," said Diogenes the Cynic two millennia ago. "It is solved by walking."

The list of famous artists, poets, and scientists who took strolls, hikes, and rambles around the city and countryside is practically endless. Wallace Stevens composed poems on his walk back and forth from the insurance agency where he worked. Friedrich Nietzsche wrote many of his books while hiking around lakes. "If I couldn't walk far and fast," Charles Dickens wrote of his twenty-mile marathons around London, "I should just explode and perish." Both Ludwig van Beethoven and Bob Dylan got picked up by

the police while wandering the suburbs—Beethoven in nineteenth-century Vienna, Dylan in twenty-first-century New Jersey. Henry David Thoreau, who used to spend four hours a day walking around the woods outside Concord, wrote, "Methinks that the moment my legs begin to move, my thoughts begin to flow."

"I set out to dispel daily depression. Every afternoon I get low-spirited, and one day I discovered the walk . . . I set myself a destination, and then things happen in the street."

—*Vivian Gornick*

Walking is good for physical, spiritual, and mental health. "No matter what time you get out of bed, go for a walk," said director Ingmar Berman to his daughter, Linn Ullmann. "The demons hate it when you get out of bed. Demons hate fresh air."

What I've learned on our morning walks is that, yes, walking is great for releasing *inner* demons, but maybe even more important, walking is great for battling our *outer* demons.

The people who want to control us through fear and misinformation—the corporations, marketers, politicians—want us to be plugged into our phones or watching TV, because then they can sell us their vision of the world. If we do not get outside, if we do not take a walk out in the fresh air, we do not see our everyday world for what it really is, and we have no vision of our own with which to combat disinformation.

Art requires the full use of our senses. Its job is to awaken us to our senses. Our screens, on the other hand, have made us lose our senses *and* our sense. Their overall effect has been a kind of spiritual numbing. "To be sensual, I think, is to respect and rejoice in the force of life, of life itself, and to be *present* in all that one does," wrote James Baldwin in his essay "The Fire Next Time." He continued, "Something very sinister happens to the people of a country when they begin to distrust their own reactions as deeply as they do here, and become as joyless as they have become." Baldwin worried that we no longer relied on our sensory experiences: "The person who distrusts himself has no touchstone for reality."

When we're glued to our screens, the world looks unreal. Terrible. Not worth saving or even spending time with. Everyone on earth seems like a troll or a maniac or worse.

"What else can you do?"

think

walk

But you get outside and you start walking and *you come to your senses*. Yeah, there are a few maniacs and some ugliness, but there are also people smiling, birds chirping, clouds flying overhead . . . all that stuff. There's possibility. Walking is a way to find possibility in your life when there doesn't seem to be any left.

So get outside every day. Take long walks by yourself. Take walks with a friend or a loved one or a dog. Walk with a coworker on your lunch break. Grab a plastic bag and a stick and take a litter-picking walk like David Sedaris. Always keep a notebook or camera in your pocket for when you want to stop to capture a thought or an image.

Explore the world on foot. See your neighborhood. Meet your neighbors. Talk to strangers.

The demons hate fresh air.

"Go out and walk.
That is the glory of life."

—Maira Kalman

CREATIVITY HAS SEASONS.

After being a nun in Los Angeles for thirty years, Corita Kent moved across the country to Boston so she could live quietly and make her art. Her apartment had a big bay window and a maple tree out front, and she liked to sit there and observe the tree changing throughout the seasons. (Something much harder to do in Los Angeles, or here in Austin, Texas, where we have two seasons: hot and hotter.)

"That tree was the great teacher of the last two decades of her life," her former student Mickey Myers said. "She learned from that tree. The beauty it produced in spring was only because of what it went through during the winter, and sometimes the harshest winters yielded the most glorious springs."

A journalist came to visit her and asked what she'd been up to. "Well . . . watching that maple tree grow outside. I've never had time to watch a tree before," she said.

She talked about how she moved into the apartment in October when the tree was in full leaf, and how she watched it lose its leaves for the rest of the fall. In the winter, the tree was covered in snow. In the spring, little flowers came out and the tree didn't look like a maple tree at all. Finally, the leaves became recognizable, and the tree was itself again.

"That, in a way, is very much how I feel about my life," she said. "Whether it will ever be recognizable by anyone else I don't know, but I feel that great new things are happening very quietly inside me. And I know these things have a way, like the maple tree, of finally bursting out in some form."

For Kent, the tree came to represent creativity itself. Like a tree, creative work has seasons. Part of the work is to know which season you're in, and act accordingly. In winter, "the tree looks dead, but we know it is beginning a very deep process, out of which will come spring and summer."

The comedian George Carlin lamented how obsessed we all are with the notion of forward, visible progress. "It's the American view that everything has to keep climbing: productivity, profits, even comedy." He felt we made no time for reflection. "No time to contract before another expansion. No time to grow up," he said. "No time to learn from your mistakes. But that notion goes against nature, which is cyclical."

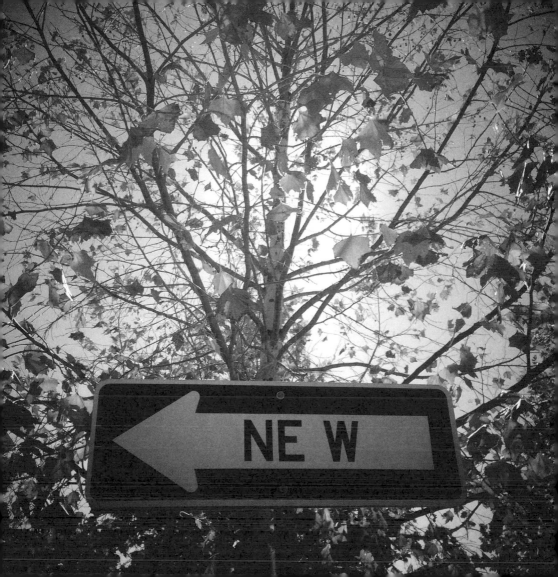

 SE~~CONDS~~ HEARTBEATS

 ~~DAYS~~ SUNRISES

 ~~WEEKS~~ MOON

~~MONTHS~~ PHASES

~~QUARTERS~~ SEASONS

~~YEARS~~ THE RETURN
 OF SPRING

You have to pay attention to the rhythms and cycles of your creative output and learn to be patient in the off-seasons. You have to give yourself time to change and observe your own patterns. "Live in each season as it passes," wrote Henry David Thoreau, "and resign yourself to the influences of each."

One way to get in touch with your own seasons is to follow Kent and Thoreau's leads and observe the seasons in nature. Draw the same tree every week for a year. Take up casual astronomy. Watch the sun rise and set for a week. Observe the moon every night for a few cycles. Try to get a feel for nonmechanical time, and see if it recalibrates you and changes how you feel about your progress.

> "Imitate the trees. Learn to lose in order to recover, and remember that nothing stays the same for long."
>
> —May Sarton

Our lives, too, have different seasons. Some of us blossom at a young age; others don't blossom until old age. Our culture mostly celebrates early successes, the people who bloom fast. But those people often wither as quickly as they bloom. It's for this reason that I ignore every "35 under 35" list published. I'm not interested in annuals. I'm interested in perennials. I only want to read the "8 over 80" lists.

I don't want to know how a thirty-year-old became rich and famous; I want to hear how an eighty-year-old spent her life in obscurity, kept making art, and lived a happy life. I want to know how Bill Cunningham jumped on his bicycle every day and rode around New York taking photos in his eighties. I want to know how Joan Rivers was able to tell jokes up until the very end. I want to know how in his nineties, Pablo Casals still got up every morning and practiced his cello.

These are the people I look to for inspiration. The people who found the thing that made them feel alive and who kept themselves alive by doing it. The people who planted their seeds, tended to themselves, and grew into something lasting.

I want to be one of them. I want to make octogenarian painter David Hockney's words my personal motto: "I'll go on until I fall over."

"There is no measuring with time, no year matters, and ten years are nothing. Being an artist means, not reckoning and counting, but ripening like the tree which does not force its sap and stands confident in the storms of spring without the fear that after them may come no summer. It does come. But it comes only to the patient, who are there as though eternity lay before them, so unconcernedly still and wide. I learn it daily, learn it with pain to which I am grateful: patience is everything!"

—*Rainer Maria Rilke*

"It is said an Eastern monarch once charged his wise men to invent him a sentence, to be ever in view, and which should be true and appropriate in all times and situations. They presented him the words: 'And this, too, shall pass away.' How much it expresses! How chastening in the hour of pride! —how consoling in the depths of affliction! 'And this, too, shall pass away.'"

—*Abraham Lincoln*

THIS, TOO, SHALL PASS.

The outer demons I mentioned in the last chapter—the men who are hell-bent on wrecking this planet, carving it up for profit like cartoon Lex Luthors—they're not going to last forever. They are going to leave this place just like us. They might take us with them, for sure. But we're all headed toward the same end. No matter what, this, too, shall pass, and they shall pass, too. I take comfort in that.

The house I live in is more than forty years old. Not that old, really, in the scheme of things, but my kids climb trees that were alive during the Nixon administration. I've learned from the older neighbors I chat with on our morning walk that the wife of the couple who built our house loved to garden. My wife has taken up gardening as well: She makes bouquets out of flowers the former lady of the house planted.

Our bathroom window looks out onto our backyard garden. When nature calls, I'll take a break from writing and I'll look out the window at my wife digging in the dirt, showing my sons the various plants, offering them the edible ones to taste. I look out on that scene and even on desperate days I'm filled with hope.

TAKE THE LONG VIEW.

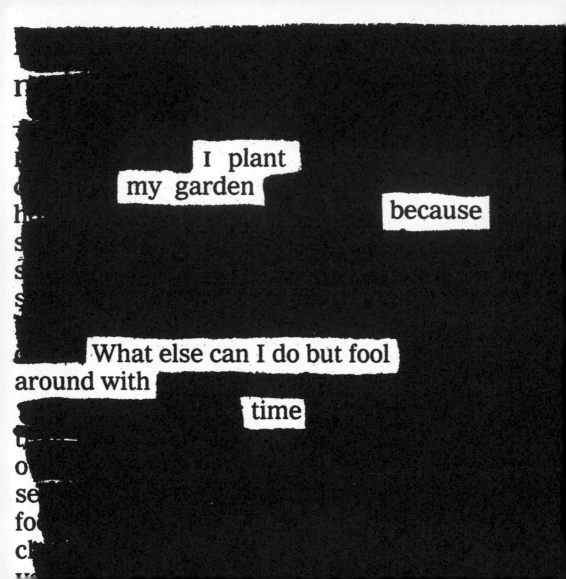

I plant
my garden

because

What else can I do but fool
around with

time

Because gardening requires so much patience and attention, gardeners have a unique sense of time and perspective.

The months leading up to World War II were some of the most terrible months in the life of Leonard and Virginia Woolf, as they "helplessly and hopelessly" watched events unfold. Leonard said one of the most horrible things was listening to Hitler's rants on the radio—"the savage and insane ravings of a vindictive underdog who suddenly saw himself to be all-powerful."

One afternoon, he was planting purple irises in the orchard under an apple tree. "Suddenly I heard Virginia's voice calling to me from the sitting room window."

Hitler was making another speech.

But Leonard had had enough.

"I shan't come!" he shouted back to Virginia. "I'm planting iris and they will be flowering long after he is dead.'"

He was right. In his memoir, *Downhill All the Way*, Leonard Woolf noted that twenty-one years after Hitler committed suicide in the bunker, a few of those purple flowers still bloomed in the orchard under the apple tree.

I don't know for sure what kinds of flowers I'm planting with my days on this planet, but I intend to find out, and so should you.

Every day is a potential seed that we can grow into something beautiful. There's no time for despair. "The thing to rejoice in is the fact that one had the good fortune to be born," said the poet Mark Strand. "The odds against being born are astronomical." None of us know how many days we'll have, so it'd be a shame to waste the ones we get.

"This is *precisely* the time when artists go to work. There is no time for despair, no place for self-pity, no need for silence, no room for fear. We speak, we write, we do language. That is how civilizations heal. I know the world is bruised and bleeding, and though it is important not to ignore its pain, it is also critical to refuse to succumb to its malevolence. Like failure, chaos contains information that can lead to knowledge—even wisdom. Like art."

—*Toni Morrison*

Whenever life gets overwhelming, go back to chapter one of this book and think about your days. Try your best to fill them in ways that get you a little closer to where you want to be. Go easy on yourself and take your time. Worry less about getting things done. Worry more about things worth doing. Worry less about being a great artist. Worry more about being a good human being who makes art. Worry less about making a mark. Worry more about leaving things better than you found them.

Keep working. Keep playing. Keep drawing. Keep looking. Keep listening. Keep thinking. Keep dreaming. Keep singing. Keep dancing. Keep painting. Keep sculpting. Keep designing. Keep composing. Keep acting. Keep cooking. Keep searching. Keep walking. Keep exploring. Keep giving. Keep living. Keep paying attention.

Keep doing your verbs, whatever they may be.

Keep going.

"THERE IS
TO BE
IN THIS

— ANTHONY

ART LEFT
MADE
WORLD."

BOURDAIN (1956 – 2018)

WHAT NOW? {

- SWITCH YOUR PHONE TO AIRPLANE MODE.
- DRAW UP SOME LISTS.
- HIRE A CHILD TO TEACH YOU TO PLAY.
- MAKE A GIFT FOR SOMEONE.
- TIDY UP.
- LIE DOWN FOR A NAP.
- TAKE A LONG WALK.
- GIVE A COPY OF THIS BOOK TO SOMEONE WHO NEEDS TO READ IT.
- SIGN UP FOR MY FREE WEEKLY NEWSLETTER AT: AUSTINKLEON.COM.

"BOOKS ARE MADE OUT OF BOOKS."

— CORMAC MCCARTHY

- HENRY DAVID THOREAU, JOURNALS

- URSULA FRANKLIN, THE REAL WORLD OF TECHNOLOGY

- NEIL POSTMAN, AMUSING OURSELVES TO DEATH

- DAVID ALLEN, GETTING THINGS DONE

- TOVE JANSSON, MOOMIN

- ANDREW EPSTEIN, ATTENTION EQUALS LIFE

- LAO TZU, TAO TE CHING

- JAMES P. CARSE, FINITE AND INFINITE GAMES

- KERI SMITH, THE WANDER SOCIETY

- ALAN JACOBS, HOW TO THINK

THIS BOOK BEGAN ITS LIFE IN MY DIARIES...

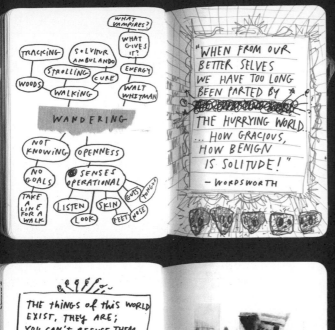

WHAT VAMPIRES?

TRACKING — SOLVITUR AMBULANDO — WHAT GIVES IT?

STROLLING — CURE — ENERGY

WOODS — WALKING — WALT WHITMAN

WANDERING

NOT KNOWING — OPENNESS

NO GOALS — SENSES OPERATIONAL

TAKE A LINE FOR A WALK — LISTEN — LOOK — SKIN — FEET — NOSE — GUTS — TONGUE

"WHEN FROM OUR BETTER SELVES WE HAVE TOO LONG BEEN PARTED BY ~~xxxxxxxxxx~~ THE HURRYING WORLD... HOW GRACIOUS, HOW BENIGN IS SOLITUDE!"

— WORDSWORTH

THE THINGS OF THIS WORLD EXIST, THEY ARE; YOU CAN'T REFUSE THEM.

— LAO TZU

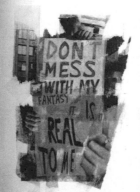

DON'T MESS WITH MY FANTASY IT IS REAL TO ME

2018 - AP

2018

2018

2017

2017

2017

2017

2017

2017

2017

2016 JUL

"THE LAST YEAR HAS FORCED US ALL INTO POLITICS.... WE DO NOT BREATHE WELL. THERE IS INFAMY IN THE AIR... [IT] ROBS THE LANDSCAPE OF BEAUTY, and TAKES THE SUNSHINE OUT OF EVERY HOUR.."

—RALPH WALDO EMERSON, 1851

4 — JUN 21

R 7 — APR 23

N 21 — MAR 6

— 2018 JAN 20

25 — DEC 11

P 4 — OCT. 24

7. JULY 20
7. SEPT 3

UNE — JULY 4

RIL — JUNE 3

RCH — APRIL 26

JAN — MAR

2017 JAN

2017 HAS BEEN A SLOW PROCESS OF __DISCONNECTING__ FROM DIGITAL LIFE AS A WAY OF __RECONNECTING__ WITH LOCAL PLACES AND THE __INTERNAL STATE.__ __WALKING__ IS THE EASIEST WAY TO DROP OUT OF THE ONLINE FEED AND ENGAGE all 5 ANALOG SENSES, TO SEEK OUT DISCOVERIES IN OUR EVERYDAY WORLD, AND THEN __WRITING__, BY HAND, ALLOWS US TO CALL FORTH WHAT IS INSIDE US, TO DISCOVER + RECORD.

WAYS OF THINKING WHILE MINIMIZING DISTRACTION

EXPLORING THE OUTSIDE WORLD

CONVERSATION

ALL FIVE SENSES

WALKING

TRACKING THE PASSAGE OF TIME

TO CALL FORTH WHAT IS INSIDE YOU

DISCONNECTING FROM THE DIGITAL WORLD

WRITING

READING

(BY HAND)

A FORM OF WALKING

RECORDING

they are really the same thing — discovering what's inside you...

MISTAKEN FOR VAGRANTS

I FIND IT CURIOUS THAT BOTH BEETHOVEN and BOB DYLAN WERE MISTAKEN FOR VAGRANTS AT THE PEAK OF THEIR ~~FORMER~~ FAME — BEETHOVEN IN THE SUBURBS OF VIENNA, and BOB DYLAN SOMEWHERE IN NEW JERSEY...

I got a flashlight out

he started drawing these
... little scenes — ...

YOU CAN
DO IT PAPA!

Jules at a monkey, and

"people"? sweet boys.

ZINES

IF I JUST MAKE
A ZINE A MONTH,
CAN I STAPLE
THEM TOGETHER
AT THE END
AND CALL IT
A BOOK?

DON'T WORRY, PAPA

I'LL ASK SIRI WHAT the TITLE OF YOUR BOOK SHOULD BE!

YOU DIDN'T LOOK LIKE YOU WERE WORKING ON A BOOK

YOU LOOKED LIKE YOU WERE WORKING ON YOUR COMPUTER

Thank you, Thank you for having me

Thank you to: my wife, Meghan, my first reader, first everything. My agent, Ted Weinstein. My editor, Bruce Tracy, and all the fine folks at Workman Publishing, including: Dan Reynolds, Suzie Bolotin, Page Edmunds, Rebecca Carlisle, Amanda Hong, Galen Smith, Terri Ruffino, Diana Griffin, and many more. Andy McMillan and the team at Backerkit Bond, for inviting me to give the talk that inspired this book, and Paul Searle and his team for filming it. My friends, colleagues, and mentors-from-afar, including: Alan Jacobs, Wendy MacNaughton, Matt Thomas, Kio Stark, John T. Unger, Frank Chimero, Kelli Anderson, Clayton Cubitt, Ann Friedman (especially for her piece, "Not Every Hobby Is a Side Hustle"), Steven Tomlinson, Steven Bauer ("apply ass to chair!"), Olivia Laing (especially for the Leonard Woolf story), Brian Eno, Brian Beattie and Valerie Fowler (that's their "Keep Going" sign in chapter 10!), Ryan Holiday, Maria Popova, Seth Godin, Jason Kottke, Edward Tufte, Levi Stahl, Laura Dassow Walls (for her excellent Thoreau biography), Deb Chachra (she introduced me to Ursula Franklin), and Lynda Barry. All my wonderful readers and smart, helpful newsletter subscribers. Finally, my sons, Owen and Jules, who are my favorite artists in the world and inspire me every day.

READ MORE!

OVER 1,000,000 COPIES IN PRINT.

AVAILABLE WHEREVER BOOKS ARE SOLD.

workman

THIS BOOK WILL TEACH YOU HOW TO BUILD A MORE CREATIVE LIFE IN THE DIGITAL AGE.

THIS BOOK
WILL TEACH YOU
HOW TO SHARE
YOUR CREATIVITY
AND
GET DISCOVERED.
↓

USE THIS NOTEBOOK TO
STIMULATE YOUR CREATIVITY
AND KEEP TRACK OF
YOUR EXPLORATIONS.
↓

NOTES